W9-CRT-302

Self-Portraits

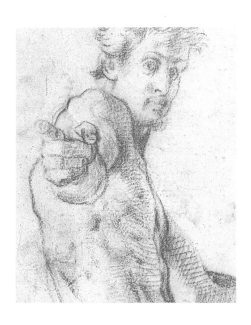

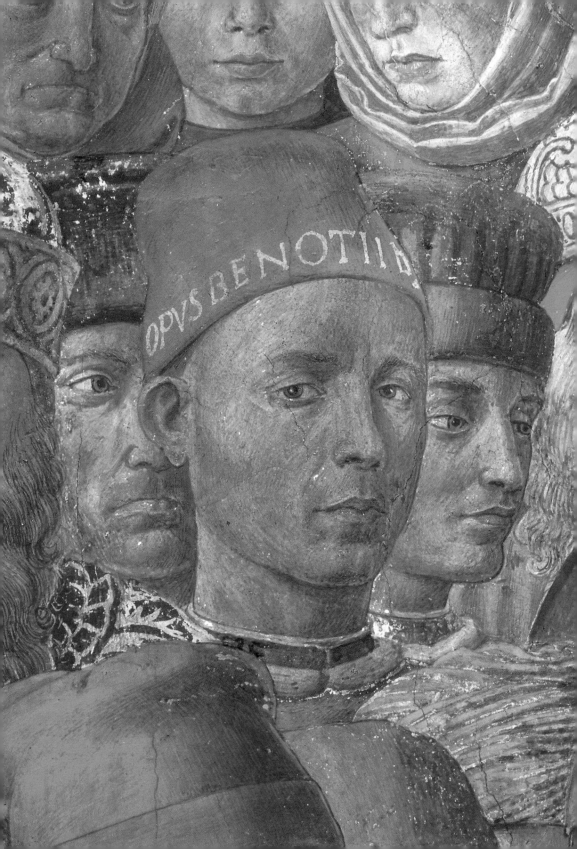

THEMES IN ART

Self-Portraits

MICHAEL KOORTBOJIAN

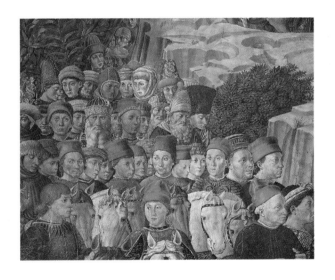

SCALA BOOKS

First published 1992
by Scala Publications Limited
3 Greek Street
London W1V 6NX

in association with
Réunion des Musées Nationaux
49 Rue Etienne Marcel
Paris 75039

Distributed in the USA and Canada by
Rizzoli International Publications, Inc
300 Park Avenue South
New York
NY 10010

ISBN 1 85759 003 1

Designed by Roger Davies
Edited by Paul Holberton
Produced by Scala Publications Ltd
Filmset by August Filmsetting,
St Helens, England
Printed and bound in Italy by
Graphicom, Vicenza

Photo credits: Artothek 30;
Rijksmuseum, Amsterdam 40; ©
RMN 6, 12, 17, 20, 22, 34, 36; Scala
(Italy) 1, 13, 16, 19, 28

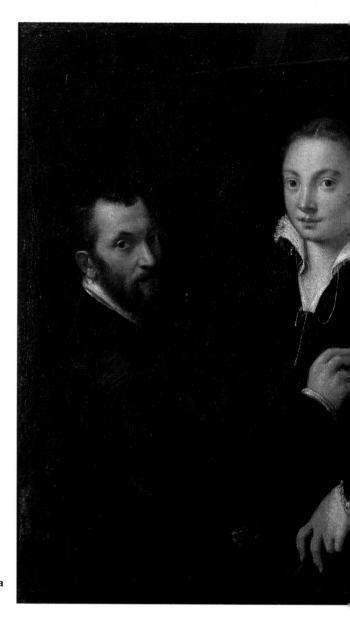

FRONTISPIECE Detail of **10** Jacopo da
Pontormo, Self-Portrait, c1525

TITLE PAGE 1 Benozzo Gozzoli
The journey of the Magi **(details),**
1459
Fresco, Florence, Palazzo Medici-Riccardi

THIS PAGE 2 Sofonisba Anguissola
Bernardo Campi painting the
portrait of Sofonisba Anguissola,
c1560
Oil on canvas, 111 × 109.5 cm
Sienna, Pinacoteca Nazionale

Contents

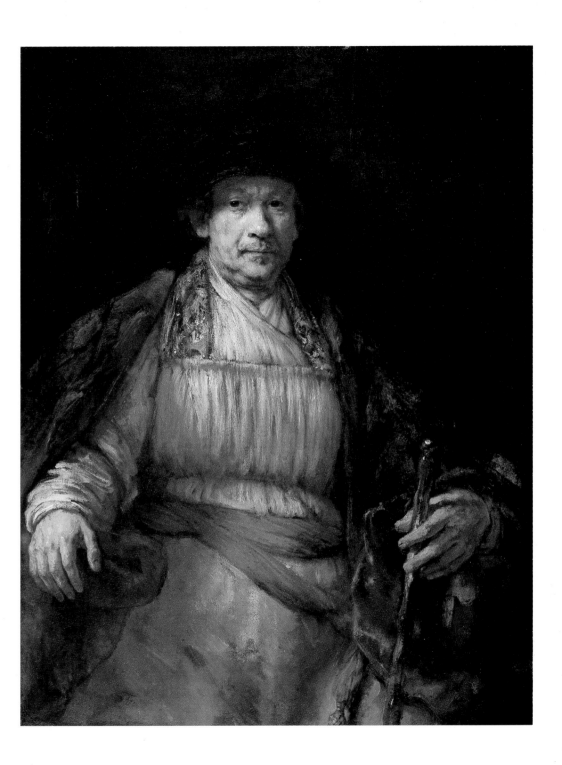

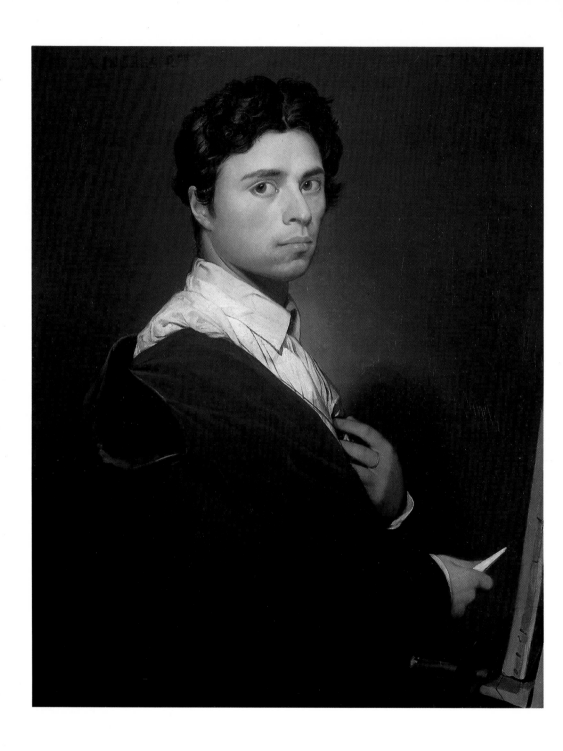

has eliminated the easel, thus subtly disguising this convention. The result is a heightened sense of informality as well as the illusion of a direct confrontation. Indeed, Chardin has employed all his technique to effect the image's apparently artless naturalism.

Rembrandt, in a late self-portrait of 1658, imposed his image upon the beholder in a very different fashion (**7**). This is the largest and among the grandest of Rembrandt's many self-portraits; over fifty painted images survive, and many more in the form of drawings and etchings. Nothing is informal here; nothing bespeaks the momentary or the spontaneous. Rembrandt, in actuality a man of modest stature, has monumentalized himself for posterity, not merely with the large size of the canvas, but in the massive proportions with which he endows himself on it. Seated in an armchair, nearly squarely facing the beholder, his immense form fills and overflows the picture's frame.

Color plays a vivid role in the work, particularly in the artist's golden garments. The brushwork is bold and the paint surface heavily textured—worked with vigor to intense effect—and the play of light across the forms enhances the dramatic quality of the image. Rembrandt's face looms out of the darkness above his enormous figure, his eyes gleam from beneath the shadow that falls across his brow, as he stares intently and calmly, seemingly undisturbed and implacable, alone in his own thoughts.

The drama of Rembrandt's self-portrayal contrasts sharply with that of a Neoclassical artist such as Ingres (**8**). With the precision of its modelling, Ingres's work attempts to reproduce appearances with a realism and fidelity that far exceeds even Chardin's. The idealization of his self-portrait derives in large measure from its emphasis on drawing, and from its attention to the most infinitesimal details. Indeed, appearances are rendered so as to achieve more than his own likeness. Ingres, like so many other artists of his day, painted under the spell of the great German archaeologist, J. J. Winckelmann, who had so eloquently proclaimed the greatness of Greek art and its "noble simplicity and quiet grandeur". In Ingres's picture the elevated sense of the man himself is to be seen in the purity of the works' forms, and comprehended in the clarity and simplicity of its contours.

8 Jean-Auguste-Dominique Ingres
Self-portrait, 1804
Oil on canvas, 78 × 61 cm
Chantilly, Musée Condé

When Ingres exhibited this painting in the Salon of 1806, it appeared rather differently. From a very early photograph we know that originally more of the canvas on which Ingres was at work was visible. The first version depicted Ingres working on his preliminary sketch as he began the portrait of the lawyer Gilibert, a painting now in the museum at Montauban. At some later date, Ingres reworked the painting to emphasize his own portrait.

Inquiry and reflection

Self-portraits depended on the use of mirrors, which were first made widely available in the fifteenth century by the evolution of glass technology. Yet the earliest mirrors were often less than perfect instruments, and many distorted the images reflected on them. Sometimes these distortions themselves became part of the artist's subject matter, as in a self-portrait by the German Renaissance artist Albrecht Dürer (9). Dürer sketched his features directly and with great rapidity, in short, nervous hatchings. The flurry of pen strokes seem to convey an agitated, unsettled state of mind. This impression seems to be underscored by the subtle deformation of the face. Yet these distortions were no doubt due to the convex mirror employed, a kind quite common during the Renaissance. Having been closest to the glass, Dürer's hand was largely unaffected, with the exception of signs of distortion along the edge of the thumb, emphasized by repeated attempts to render the outline. A very similar fascination with these visual effects is found in a contemporary self-portrait painted by Parmigianino, now in Vienna.

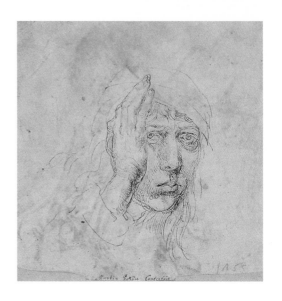

The mirror was used to render more than just the artist's face. The study of anatomy from living models characterized one of the chief aspects of Renaissance naturalism, and rigorous description of the nude figure quickly became a hallmark of artistic training. These drawings have come to be known as "academies." They, too, could be done with the aid of the mirror, from early on.

One example is a quick sketch by the Florentine Mannerist painter, Pontormo (10). The artist is depicted from head to knee, almost completely naked. He turns his head to glance over his shoulder, as his eyes follow his vividly pointing outstretched arm. The draw-ing is executed in bold, rapid strokes, with which Pontormo captures the individuality of his figure and pose. The work was not primarily conceived as a self-portrait, but above all as a studio exercise in exaggerated foreshortening, with its essential focus the arm extended toward the mirror. Despite the private nature of this study, one not intended for other observers, Pontormo heightened its drama by the elimination of its studio setting. The artist's left hand disappears beyond the image's edge, toward where it must have lain upon his easel; there he no doubt held the paper upon which the drawing itself was made. The artist's two outstretched arms thus chart the double axis of his alternating focus, between the image he sees and the image he draws.

The spontaneity of Pontormo's drawing, and the near violence with which it appears to assault the beholder, is absent from Dürer's famous study of himself in the nude (11). Dürer's figure is a more deliberate work—more carefully modelled, more subtly employing its similar patterns of hatched and parallel lines. By its freer handling, the face is

9 Albrecht Dürer
Self-portrait, c1493

Pen and ink, 20.4 × 20.8 cm
Erlangen, University Library

Perhaps we witness here Dürer's attempt to record a fit of melancholy, that imbalance of the natural humours which was traditionally believed to afflict artists, and which Dürer was to epitomize with his famous engraving *Melencolia I.*

10 Jacopo da Pontormo
Self-portrait, c1525

Red chalk, 28.4 × 20.2 cm
London, British Museum

In this highly personal study, Pontormo dramatically confronts his own image, conflating his simultaneous roles as both artist and model.

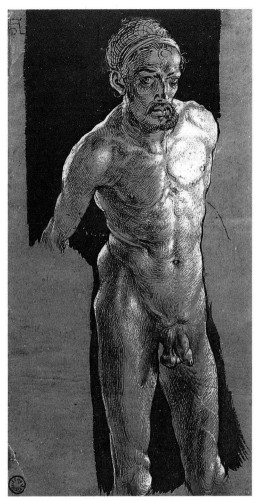

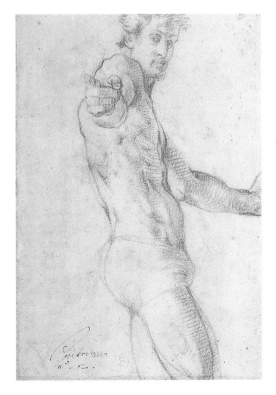

11 Albrecht Dürer
Self-portrait in the nude, c1503

Pen and wash with white heightening, 29.1 × 15.3 cm
Weimar, Schlossmuseum

This self-portrait, contemporary with Dürer's earliest studies of proportion as well as his famous engraving of *Adam and Eve*, reveals another facet of the artist's preoccupation during this period with the systematic study of the human form.

differentiated from the body, which was Dürer's primary focus. He not only carefully rendered the physical forms, but also studied the fall of light across them, highlighted by added hatchings in white. Unlike Pontormo, Dürer purged his work of both drama and idealization, attempting to render his own form with honesty and conviction.

While the availability of mirrors afforded artists new opportunities to take their own images as subjects, certain conventions soon followed from their use. Those artists desirous of innovation rose to the challenges presented by their medium and sought out new pictorial solutions. A second pastel self-portrait by Chardin (12), completed four years after the first (6), provides a telling example. There is nothing of the casual pose found in the earlier picture, nor of its suggestion of the artist surprised at his work. Head erect, unmoving, dispassionate, Chardin here gazes directly outward. He now peers through his spectacles, his eyes framed by their circular rims. The twin round forms draw the beholder's attention to the artist's gaze emanating from the work's center. His spectacles are a tool of his trade, and they underscore Chardin's absorption in the artist's critical act of seeing. Yet what commanded Chardin's attention here was the study of his own image, and the work's powerfully confrontational effect derives from this. Here the detailed, prolonged scrutiny that the mirror allowed was employed by Chardin, paradoxically, to heighten the picture's effect of immediacy, to enhance the fiction that its subject is truly there, gazing toward us.

The very use of a mirror, and the pictorial conventions that its use entailed, might furnish a painting's theme. This seems to be the case with a curious self-portrait by the obscure seventeenth-century painter, Johannes Gumpp (13). The artist appears with

12
Jean-Siméon Chardin
Self-portrait, 1775
Pastel, 46 × 38 cm
Paris, Louvre

In this later portrait Chardin displays a softer treatment of the forms than he had employed in 1771 (6). The individual hatchings, as if to sculpt the features, are here blended together, the garish lighting has been muted, and the angularity of the forms – of the facial features as well as of the draperies – has disappeared.

his back to the spectator, engaged in his work. To his left we see the mirror in which he studies his visage, and to his right the painting on which he labors. Gumpp's work seems to allude to the famous "dispute" between the arts of painting and sculpture, in which it was claimed that painting, with the aid of the mirror, could equal the three-dimensionality of sculpture. Indeed, this is borne out by the precedents this method of "triple portrait" brings to mind: one of an unknown man painted by Lorenzo Lotto about 1535 (now in Vienna, Kunsthistorisches Museum); one of Charles I of England by Van Dyck, dating from about 1635 (now at Windsor Castle); and another of Cardinal Richelieu painted by Philippe de Champaigne in 1642 (now in London, National Gallery). The purpose of the latter two examples was to provide models for marble portrait busts. Both were sent to Rome, the first to be sculpted by Francesco Mocchi, the other by Gian Lorenzo Bernini, and perhaps Lotto's work was painted with the same intention.

13 Johannes Gumpp
Triple self-porrait, 1646
Oil on canvas, 88.5 × 89 cm
Florence, Uffizi
The means by which Gumpp captured his likeness from the mirror is recorded in the contrast of the left and right images – but he has left us to imagine the arrangement of mirrors by which he was able to portray himself from the rear.

Images of the artist's status

"The painter sits, well dressed and perfectly at ease, before his work. He wields a very light brush dipped in delicate color. He is adorned with the clothes that please him; his home is clean, filled with charming pictures, and he is often accompanied by music or by the reading of a variety of beautiful works."

Leonardo's account of the painter's appearance was an ideal one—and it is not surprising that he portrayed himself in a very different fashion, as we have seen (**3**). However, something similar to his description is found in the magisterial self-portrait of the aged, contemplative Titian (**15**), which the artist appears to have painted for himself, to keep in his home. Nevertheless he presented himself elaborately attired in fur and brocade, all in black—the color most suited for attendance at court, as Baldassare Castiglione had noted in his treatise *The Book of the Courtier*. Around Titian's neck hangs the gold chain awarded him by the Emperor Charles V, and in his hand the painter holds a brush, as if a reminder of the art which had earned him this honor.

Similar attempts by artists to exalt their standing are a constant feature in the history of self-portraiture. Despite the honors often bestowed upon them, artists were still burdened by their traditional identification as craftsmen, an association that was deeply entrenched in societies ordered by distinctions of class. Titian, Dürer, or Rembrandt, as well as many others, might be declared a "new Apelles"—the equal of that most celebrated painter of Greek antiquity—and yet to be among those honored by knighthood was deemed a grander compliment and a more

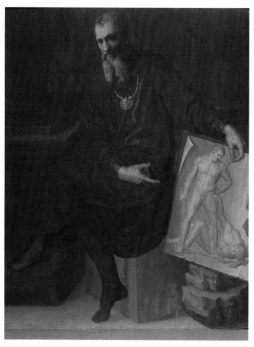

14 Baccio Bandinelli
Self-portrait, c1540
Oil on panel, 142.2 × 112.8 cm
Boston, Isabella Stewart Gardner Museum
**The full length self-portrait is unusual, and
with its complex pose – legs crossed and arms
extended, with upper and lower body turned in
opposite directions – was no doubt intended by
Bandinelli, by no means a shy man, as a display
of his artistic prowess.**

15 Titian
Self-portrait, c1558
Oil on canvas, 86 × 65 cm
Madrid, Prado
**The official painter to the Emperor Charles V
as well as the Venetian state and later Philip II
of Spain, the aged painter portrayed himself in
all his grandeur. He proclaims his
accomplishments with the imperial gold chain
about his neck, and with his brush, the means
by which they were achieved.**

important form of recognition.

Such recognition is exemplified by a self-portrait of Titian's contemporary, the Florentine sculptor Baccio Bandinelli (**14**). His full-length painted portrait (he was a painter, too, although hardly a successful one) shows him seated, handsomely attired as a Knight of the Order of St. Iago, an honor bestowed upon him by Charles V in 1529. The badge of the Order, a red cross on a shell, is proudly displayed on the gold chain that hangs around his neck. This picture, like that of Titian, is most likely one kept in his own house, which Bandinelli mentioned in his diary.

Beyond recording his likeness and attesting to his modest skills in this art, Bandinelli's painting may document the artist's response to the most unfortunate event of his professional career—the hostile reception of his monumental *Hercules and Cacus*, to which the drawing held in his hand alludes. This drawing differs from the marble work he sculpted, which is still standing outside the portal of the Palazzo Vecchio in Florence, and from the wax model of a variant composition now in Berlin, as well as from all the surviving studies for the work. The pose of Cacus, stretched out on the ground below the triumphant Hercules, suggests that it records Bandinelli's original plans for the monument, before he realized that the marble block he was to carve was less colossal than had been thought. Since the apparent age of the artist dates the painting after the completion of the sculpted monument in 1534, it may be imagined that here we see Bandinelli answering his critics. The artist displays his early design, as if to demonstrate his original intentions for the work, the final form of which had been dictated first by the dimensions of the marble he inherited with the commission, and then by the choice of his patron, the Pope.

For women artists, certain forms of social

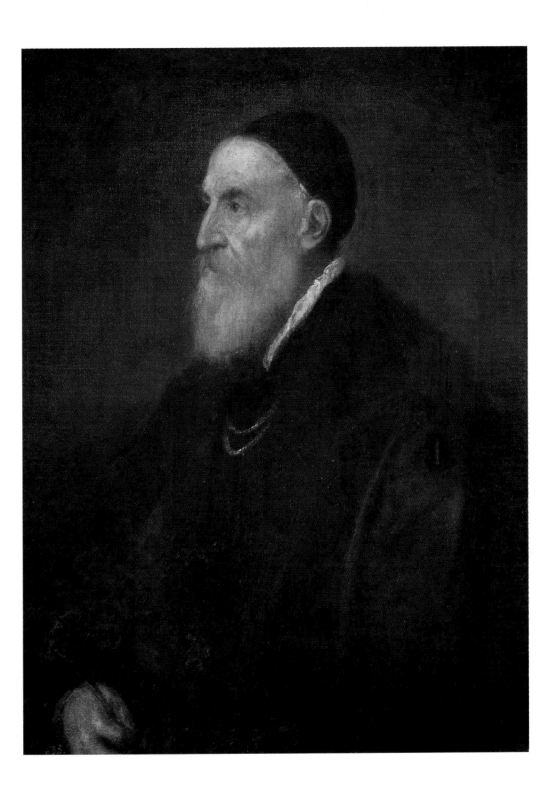

recognition were beyond reach, and their self-portraits often celebrated their other accomplishments beyond that of their art. An example is the self-portrait of the late Renaissance Bolognese artist, Lavinia Fontana (**16**). Dignified and poised in an elaborately fashionable costume, she appears performing at the clavichord, while behind her a maidservant holds open a music book. She seems hardly what one expects to find in a painter's studio. Yet an inscription above declares her to be the daughter of the painter, Prospero Fontana, and that she has here taken her own likeness from a mirror in the year 1578 at age twenty-six. By the window in the background stands an empty easel, the solitary emblem of her true art. But in the late sixteenth century a proficiency in music was deemed a proper accomplishment for young women, and it is as both proper and accomplished that Lavinia primarily wished to present herself.

Music was an accomplishment not reserved for women and appears in many paintings to symbolize the breadth of an artists' creativity. When Paolo Veronese depicted himself in the foreground of his *Marriage at Cana* (**17**), together with his Venetian contemporaries Titian, Jacopo Bassano, and Tintoretto, they appeared in the role of musicians. The scene recalls, if only by implication, the ancient rivalry between the arts, and the long-standing battle to elevate painting as an equal to the traditional seven "Liberal Arts" of which music was a member.

On the other hand, when the Dutch seventeenth-century artist Jan Steen chose to portray himself as a musician, the work took the form of a caricature. In a picture in the Thyssen Collection, Steen's lute-playing bohemian appears as a jester, a role common to the amateur theatrical productions of his day. The oversized tankard on the table before him sets the picture's jovial tone, and

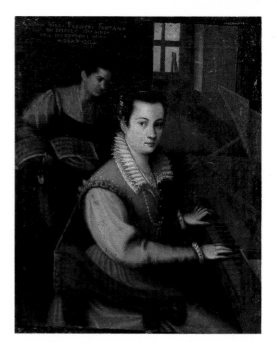

16 Lavinia Fontana
Self-portrait at the clavichord, 1578
Oil on canvas, 27.5 × 24.9 cm
Florence, Palazzo Pitti
The inscription reads: "Lavinia, the virgin daughter of Prospero Fontana, from the mirror portrayed here her own likeness, in the year 1578."

17 Paolo Veronese
The marriage at Cana, 1562–63
Oil on canvas, 669 × 990 cm
Paris, Louvre
This huge canvas was commissioned for the wall of Palladio's new refectory for the Benedictine convent of Santa Maria Maggiore in Venice. Veronese's self-portrait (foreground, in white) along with several of his contemporaries, notably Titian (to the left, playing the *viola de gamba*), adding a charming note of realism to this spectacular biblical scene.

Detail of 17

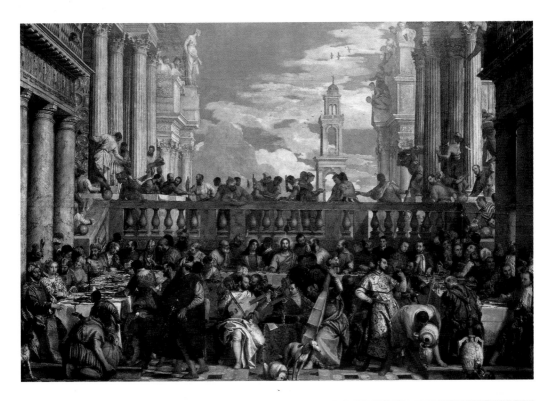

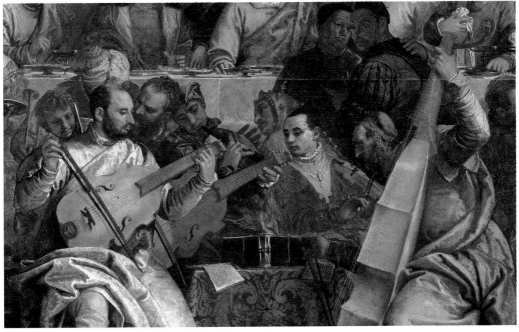

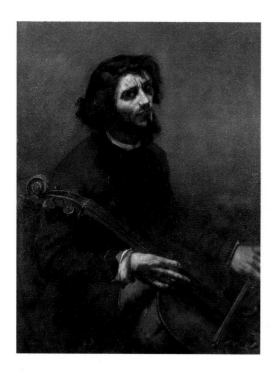

18 Gustave Courbet
Self-portrait: *The cellist*, 1847
Oil on canvas, 117 × 90 cm
Stockholm, Nationalmuseum

**It has been suggested that, in conformity with
Courbet's long-acknowledged interest in
"popular" imagery, his choice to portray
himself as a musician was made in emulation of
George Sand's heroine, the street singer of
Consuelo.**

19 Carlo Dolci
Self-portrait with drawing, 1674
Oil on canvas, 74.5 × 60.5 cm
Florence, Uffizi

**Filippo Baldinucci wrote of his friend Dolci:
"... so many calamities beset poor Carlo ...
because of a pernicious melancholic humor ...
it was no longer possible to have from him so
much as a word, but only, in sighs, the effect ...
of a mortal anguish of the heart."**

his jaunty air and foolish grin complete the satire.

This penchant for music among painters, and for portraying themselves as practitioners of this "sister art," continued through the centuries. Gustave Courbet presents himself as a 'cellist, nearly full-length and life-size, in a self-portrait of 1847 (**18**). This is merely one of the many guises in which Courbet was to cast himself in numerous self-portraits. His sombre figure, with shadowed face, has often been regarded as evidence of Courbet's preoccupation with the portraits of Rembrandt. In the painting Courbet appears, somewhat disconcertingly, to play the 'cello left-handed; this is no doubt a sign of his having posed, together with his instrument, before a mirror, which thus produced a reversal of his image.

Other artists were less pretentious, content to portray themselves merely as the professionals they were, and to let their work make their claim for recognition. Another Florentine, Carlo Dolci, portrayed himself with a drawing in hand (**19**). The drawing reproduces a pencil sketch (now in the Uffizi), which augments the painted image. Both display Dolci's extraordinary gifts as a portraitist, yet to different effect. The sketch reveals his facility to render both faces and costumes with an uncanny sensitivity to detail. The painting, however, demonstrates his ability to infuse those features with profound psychological content. Gazing listlessly from the shadows, the artist's sad features betray the gloomy mood of a man burdened by melancholy, from which Dolci is known to have suffered. The nobility of his art, in the practice of which Dolci might appear wholly inspired, as the small drawing so eloquently reveals, is contrasted here to the man from whom that inspiration might flee, leaving him desolate and brooding at the mundanity of life.

The self-portrait of an artist who worked in

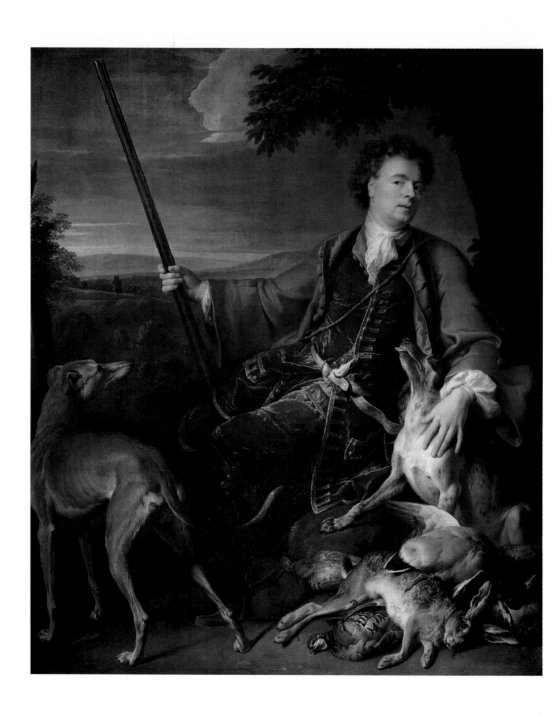

painting's lesser genres might prove even humbler. François Desportes, known primarily as a painter of still lifes and genre subjects, employed his skills advantageously to augment his portrait (**20**). The specificity with which the dogs and the dead game are depicted, as well as the details of his costume, provide examples of his careful studies from life. Yet the awkward conjunction of the foreground scene with the vista behind, and the evident contortion with which the head is joined to the body, betray not only the work's limitations, but its piecemeal composition and assembly, with its elements studied individually as they were for so many of Desportes's still-life paintings.

20 François Desportes
Self-portrait as a hunter, 1699
Oil on canvas, 197 × 163 cm
Paris, Louvre
The detailed studies of animals testify to Desportes's renown as a still-life painter, while the awkwardness of his own pose and the landscape background suggest the limitations of the artist's skills.

Witnesses present at the event

Leon Battista Alberti (**4** and **5**) concluded his treatise on painting of 1435, *De Pictura*—the first such treatise to be devoted to the art—with a plea to the painters of his day who might profit from his work: "If [this book] is likely to be of some use and convenience to painters, I would especially ask them as a regard for my labors to paint my portrait in their stories and thereby proclaim to posterity that I was a student of this art and that they are mindful and grateful for this favor."

If any artist so honored Alberti and responded to his wish, the work has not been found. Yet the practice was a common one, and many Renaissance pictures, often of religious events that transpired in the distant past, feature the portraits of contemporary persons. Recognizable faces amidst such scenes declared those figures to be witnesses to the events: their imagined presence was a testimony to their religious faith. Frequently painters included themselves among the onlookers, not only recording their own images for posterity, but claiming the painting's excellence as their own achievement. Artists were also proud to show themselves beside their patrons, who as donors of religious works were commonly portrayed in the paintings they commissioned.

Around 1460, Benozzo Gozzoli included himself among the throng who attended the *Journey of the Magi* in his frescoed decoration of the Palazzo Medici's chapel (**1**). His youthful face appears among the numerous retainers of Cosimo and Piero de' Medici, who are shown leading the crowd that follows the three Magi on their journey. On his cap, the artist both identifies himself and signs his

work, OPUS BENOTTI (the work of Benozzo).

In much the same way, though without a signature, Sandro Botticelli also displayed his portrait and asserted his presence alongside the Medici in an altarpiece he painted during the mid-1470s for the Florentine church of Santa Maria Novella (**21**). Here the Magi themselves are portraits of the most illustrious members of the Medici family, and Botticelli has included himself among their entourage. He stands at the extreme right of the picture, where he stares out toward the faithful, who gathered before the altar on which the work was once placed. He appears distracted by our presence, and turns up to acknowledge us. As Botticelli exploits the conventional glance over his shoulder that resulted from his use of the mirror, he takes on a role like that recommended by Alberti in his *De Pictura*: "I like there to be someone in the story who tells the spectators what is going on, and...beckons them with his hand to look...." Botticelli acknowledges his painting's beholders, as if to solicit our participation in the event. From amid the crowd, a second figure also looks out toward us, gesturing with his hand, who may well be Guaspare de Lama, the patron for whom the painting had been made.

Botticelli endeavored to heighten the illusion of the beholder's presence at the depicted event. The high vantage point and sloping ground-plane lead the viewer's eye rapidly toward the center of the composition, where Botticelli had situated the Virgin and Child, to whom the Magi come and present themselves and their gifts. He has here transformed the customary representation of the story, which had traditionally shown the grand sweep of the cortège, and the procession of the Magi across the picture, from left to right, toward the Virgin, as Gozzoli had presented it and as he himself had done in an earlier version of

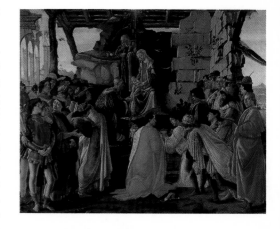

21 Sandro Botticelli
The Adoration of the Magi, c1475
Tempera on panel, 111 × 134 cm
Florence, Uffizi
The picture was originally painted for the funerary chapel of Guaspare del Lama in the Florentine church of Santa Maria Novella. Botticelli portrayed in leading roles both the older and younger members of the Medici family.

Detail of 21

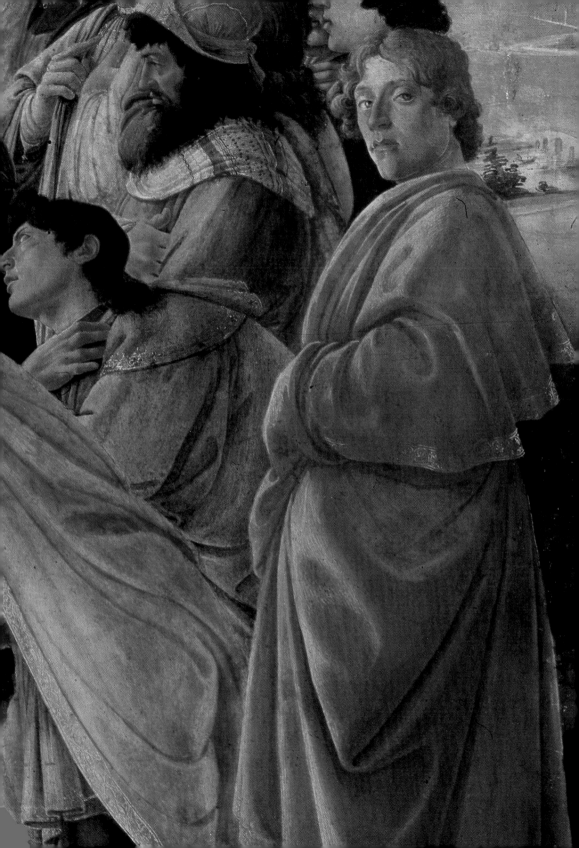

22 Hans Sebald Beham
The story of King David, 1534
Oil on panel, 128 × 131 cm
Paris, Louvre

The four episodes of the biblical tale are: the women of Jerusalem greet Saul and David;
Bathsheba at her bath; David sends Uriah to the siege of Rabbath; and the Prophet Nathan before
David.

this theme (now in London).

Not all paintings that include portraits and self-portraits do so with such dramatic emphasis. At times the physical nature of the work, or its intended setting, might call for more modest effects. Less dramatic than Botticelli's self-portrayal is one by a Nuremberg artist of the early sixteenth century, Hans Sebald Beham (**22**). The only surviving painting by Beham, it appears on a painted tabletop made for Cardinal Albrecht of Brandenberg, and illustrates four episodes of the *Story of King David*. At the far left edge of the scene that depicts *Nathan's reproach of David*, as if watching from the wings, stands the artist. Beham has divorced himself from the history his picture relates by means of a prominent balustrade on which his hand rests, conspicuously holding the draftsman's compass as an emblem of his art.

These Renaissance images had medieval precedents, although the earlier artists had seldom approached their work so self-consciously. Matthew Paris, a thirteenth-century English friar from the monastery at St Albans, north of London, depicted himself kneeling in prayer beneath an image of the enthroned Virgin and Christ Child (**23**). Once an independent work of art in its own right, this drawing now serves as the frontispiece to Matthew's own manuscript of his *History of the English People*. The added inscription records the prayer Matthew is shown reciting to the image of the Virgin and Child, which may represent a wooden sculpture from the church at St Albans that is now lost. Matthew distinguished between the living man and the wooden work of art both by the colors which adorn the Mother and Child and by the frame that surrounds them. Thus he takes no credit for their creation, nor does he portray himself as an artist. As he bows in prayer before the Virgin and Child, he demonstrates by his

Detail of 22
On the wall behind his self-portrait, an inscription records Beham's signature and the work's dedication and date (**1534**), along with his declaration that the painting had been made for Cardinal Albrecht of Brandenberg "with the utmost care."

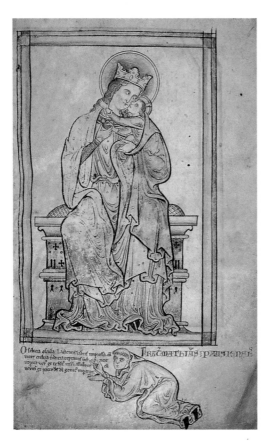

23 Matthew Paris
Frontispiece to *The History of the English People*, *c*1250

Pen, ink and wash on vellum, 35.5 × 23.5 cm
London, British Library, MS Royal 14.C.VII, fol. 6

Matthew's prayer reads: "Oh happy kisses impressed on such tender lips. Just as among the many signs of crawling infancy, the true Son played thanks to you his mother, so thanks to God His Father the true-born God may rule."

action what one should do before such holy images, how they are to be regarded, and how they are to be revered.

Seldom do works of art, especially self-portraits, so directly address the function and purpose of images. However, almost three hundred years after Matthew Paris, a Spanish artist of the Counter-Reformation, Francisco Zurbarán, was to produce an image that, despite its obvious differences, evokes similar artistic intentions (**24**). Unlike Matthew Paris, who distinguished himself from the polychrome sculpture before which he prayed, Zurbarán vividly depicts the crucified Christ as if He were real, and present before him.

Although not an artist whose work is distinguished by strikingly original compositions, Zurbarán has nonetheless depicted here a subject unprecedented in Spanish painting, *St. Luke before Christ on the Cross*. As the patron saint of painters, Luke was frequently given the artist's own features, yet he was traditionally portrayed painting the Virgin. There is nothing in the story that justifies placing him at the foot of the crucified Savior, as Zurbarán has done here. It is in the guise of the saint that the painter offers homage to the greatest of devotional images—as if it were real—and takes the liberty of casting himself as a witness to the event.

24 Francisco de Zurbarán
***St. Luke before Christ on the Cross*, *c*1630–35**
Oil on canvas, 105 × 84 cm
Madrid, Prado

Zurbarán has distinguished the two figures only subtly, by a slight difference in scale, and thus exploits the illusion that the painter is indeed present at the event.

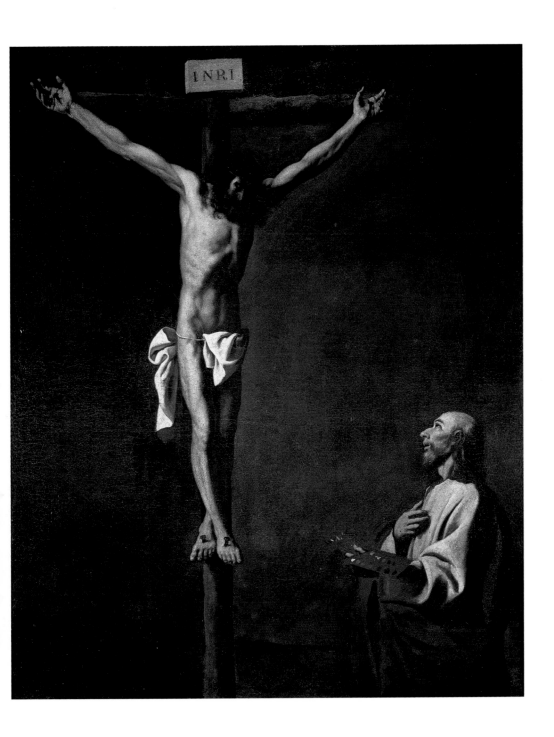

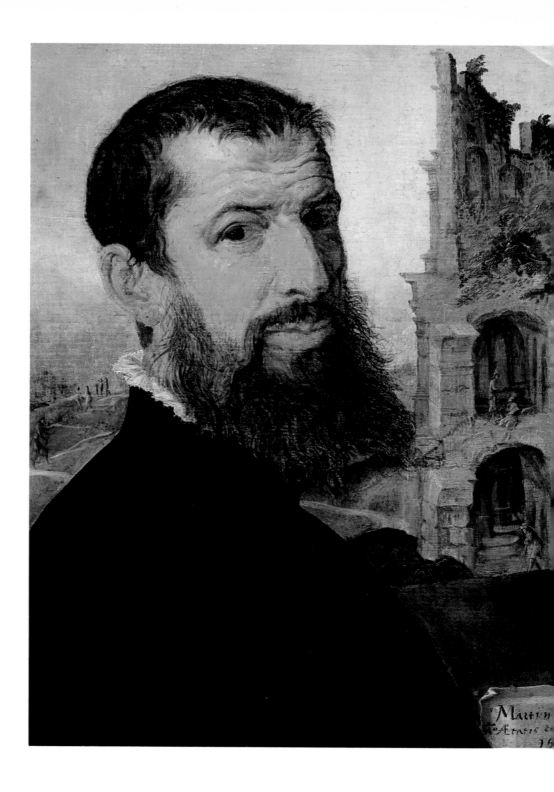

34

Remembrance and Commemoration

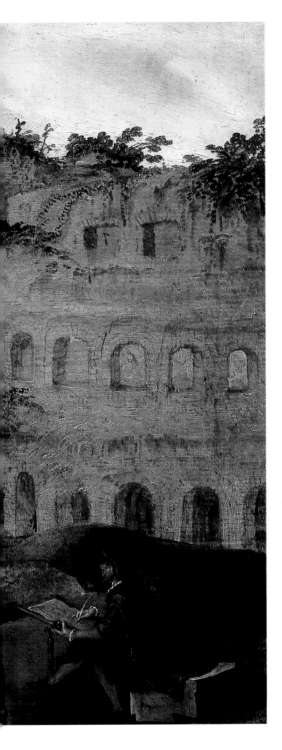

The Netherlandish painter Maerten van Heemskerck's self-portrait is set before a landscape view of the Roman Colosseum (**25**). Such a visit to study Rome and its ancient monuments had provided a fundamental stage in the training of artists from all over Europe from the sixteenth to the nineteenth centuries. At the right, Heemskerck is shown at work, drawing amid the ruins, as he had actually done, producing a famous series of drawings of Roman antiquities during his visit in the 1530s. Yet on the small slip of paper illusionistically placed along the lower edge of the picture, the work is signed and dated 1553, and the painting, done nearly twenty years after the event it so quaintly records, is actually an imaginative act of reminiscence.

All self-portraits are fundamentally commemorative. Like Heemskerck's they might record past events, they might make absent friends present, or even preserve the living image of those now dead. To do so, certain examples relied, paradoxically, on the depiction of imaginary settings, and on the portrayal of truly fictitious events. Sofonisba Anguissola, in a cleverly devised conceit, was to portray herself being painted by the master with whom she had trained, Bernardino

25 Maerten van Heemskerck
Self-portrait before the Colosseum, 1553
Oil on panel, 42.2 × 54 cm
Cambridge, Fitzwilliam Museum
While in Rome Heemskerck compiled sketchbooks filled with studies after the many antiquities he found throughout the city. Many of these drawings survive, bound together in two albums, now in Berlin.

Campi (**2**). Anguissola has masterfully distinguished between the apparently living Campi and her own portrait on which he is shown at work. He appears interrupted at his task, turning to face the beholder, in the conventional over-the-shoulder pose so often the sign of a self-portrait, used ingeniously here to aid in the fiction that he is the author of the work before us. By contrast, the true self-portrait is presented somewhat stiffly, slightly larger in scale, seated, and in three-quarter view.

Portraits might not only conceal the distinction between the living and the painted, but, more frequently, between the living and the dead, as Dürer had done in his *Martyrdom of the Ten Thousand* (**26**). The painting recalls other religious works, such as Botticelli's (**21**), in which the artist included recognizable figures who appear as participants or witnesses to the depicted events. Yet here the commemorative purpose of the portraits has taken on a distinctive prominence, one confirmed by our knowledge of the subject, the setting, and the patron.

Dürer's painting represents the vengeance of a legendary fourth-century Persian ruler, Shapur the Great, who drove the newly Christianized Romans from Asia Minor. This horrific episode included not only the torture of the Christian soldiers in an attempt to make them recant, but even their crucifixion. The picture's deep landscape is filled with the representation of many tortures and a vast array of figures, all of which are carefully described in gradually receding scale in a skilled application of the rules of perspective. Amid the fury, at the very center of the scene, Dürer walks alongside the recently deceased Conrad Celtes, their dark garments setting them apart from the surrounding fray. The painter here commemorated his humanist colleague and their friendship for their mutual patron, Frederick the Wise, ruler of Saxony.

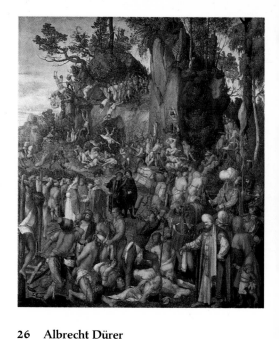

26 Albrecht Dürer
The martyrdom of the ten thousand, **1508**
Oil on panel, transferred to canvas, 99 × 87 cm
Vienna, Kunsthistorisches Museum
Dürer painted the work in 1508 for the Elector Frederick the Wise of Saxony. The horrific subject was probably chosen by Frederick himself, who owned relics that purported to be of the ten thousand martyrs.

Detail of 26

Painting might bring together the living and the dead in a more personal manner. Such was the case in another multiple Renaissance portrait, where two stepbrothers, the painters Ventura Salimbeni and Francesco Vanni, appear together with their parents (**27**). A recognizable difference in the style of Vanni's portrait, on the left, suggests that this was a joint effort. Their father's was clearly done posthumously, since Arcangelo died in 1579 when his sons were still in their early teens. The stiffness in the handling of his features distinguishes his image from one worked from life. The work may originally have been merely a triple portrait, in which the two artists commemorated their father, who had also been a painter. The image of Francesco's mother, Battista, awkwardly squeezed between her husband and son, disrupts an otherwise harmonious composition and seems to have been an afterthought, inter-posed to produce this striking "family portrait."

Commemoration was the central theme of one of Peter Paul Rubens's most haunting works that included his self-portrait, the so called *Four philosophers* (**28**). Painted in 1615, the picture presents the artist, standing at the far left, with three other men gathered about a table: to the right of the painter sits his brother Philip; next, the famous philosopher, Justus Lipsius; on the far right sits Jan Woverius. The

**27 Ventura Salimbeni and Francesco Vanni
Self-portraits with their parents, c1600**
Oil on canvas, 85.5 × 104 cm
Florence, Uffizi

The two painters have commemorated their father and Francesco's mother in this picture. The father had died some twenty years earlier, and the clumsy introduction of the mother's portrait suggests that she died when the work had been substantially completed.

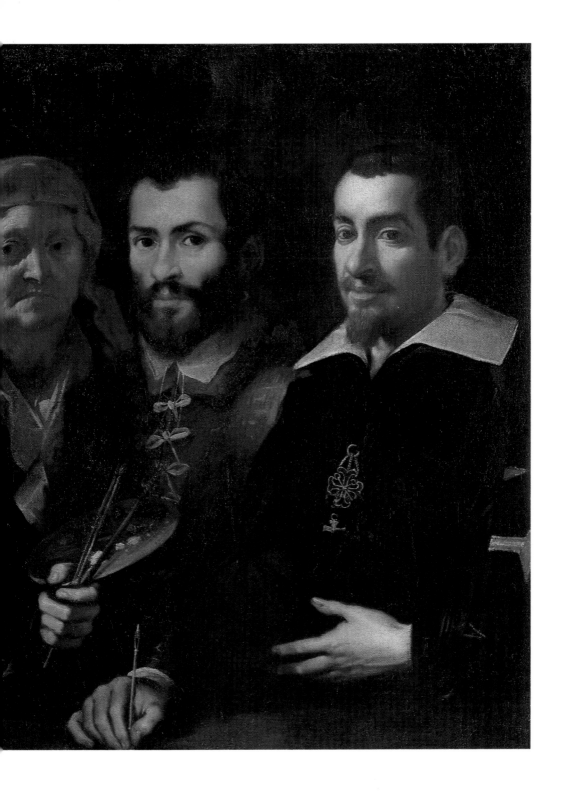

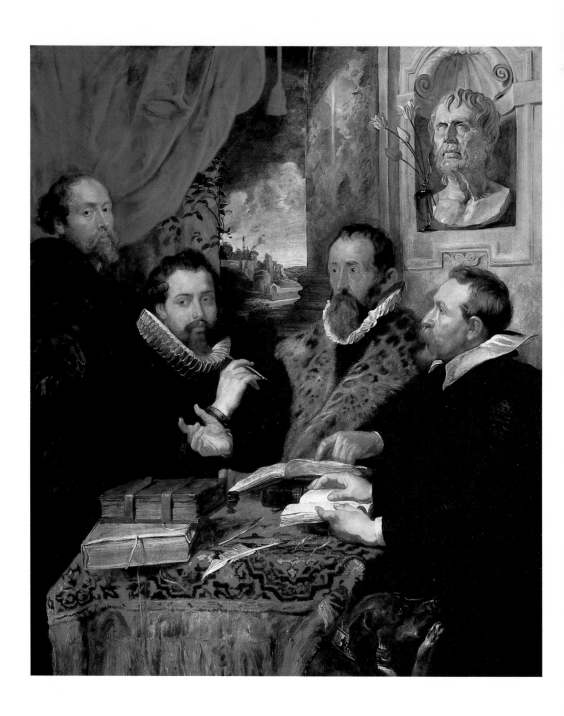

picture is a reenactment of their friendship, for at the time the work was painted Philip Rubens and Lipsius were already dead. The painter alludes to the difference between the dead and the living with the vase of tulips overhead, two of which appear full-blown, the other two yet to blossom. The subtle sense of the two central figures' psychological isolation must be attributed to Rubens's need to rely on available images for their portraits. For that of his brother, the artist employed a painting he had completed in 1610, the year before Philip died. For that of Lipsius he seems to have had recourse to an earlier portrait by Abraham Janssens.

Rubens has imagined the four men gathered in study, as a fitting memorial to the intellectual pursuits that bound them together in friendship. Both Philip Rubens and Woverius had been students of Lipsius, and the three assume here their familiar roles, as the master points to a passage in the book open before him, and gestures as he explicates it. The subject must be the Stoic philosophy of Seneca, whose writings Lipsius had edited: he was the great authority of the period on the philosopher's works. As if to leave no doubt, Rubens has placed an ancient portrait bust thought at the time to depict the Roman philosopher in the niche above Lipsius's head.

Undoubtedly the greatest of these complex

28 Peter Paul Rubens
The four philosophers, c1612–15
Oil on panel, 167 × 143 cm
Florence, Palazzo Pitti

Rubens's group portrait includes even Justus Lipsius's dog, Mopsus. He serves here to recall how his philosopher-master had felt not only that all learned men should keep dogs as pets, but that in the unrelenting pursuit of their studies they should, "following the example of the dog ... pass day and night without sleep."

self-portraits, and deservedly the most famous, is Velázquez's *Las Meninas* (**29**). The scene takes place in 1656 and is set in an apartment of the Spanish Royal Palace that had been transformed, some ten years before, to serve as the court painter's studio. At the centre stands the Infanta Margarita, the young heiress to the throne, surrounded by her maids (the *meninas* from whom the painting has taken its name), several dwarfs and her dog. To the left stands Velázquez, who is dressed in the fashionable attire of a courtier. With brush and palette in hand, he is at work on a large canvas, of which only the back can be seen.

Nearly all the figures stare out toward the beholder, and the object of their gaze is revealed in the mirror on the rear wall. There, reflected in the glass, are King Philip IV and Queen Marianna, side by side. It is the royal couple, standing before the scene, who command the attention of all concerned. Thus the work comprises at once self-portrait, group portrait, and royal portrait.

Yet Velázquez has disguised the precise nature of the work's narrative and significance, and his ingenious composition has engendered long and heated debate. Were the King and Queen present before this scene, posed to furnish the subject of the painter's huge canvas? No such portrait is known to have existed. Or, have they just entered the room where the artist is at work, and if so, what then was the subject of the monumental canvas, hidden from view? These ambiguities forcefully grip the painting's spectators, who seem as if to stand in the very place that had been occupied by the King and Queen. As it imposes upon all of its beholders this place of honor, Velázquez's picture seems to envelope them within its complex composition and to challenge them with its pictorial riddle.

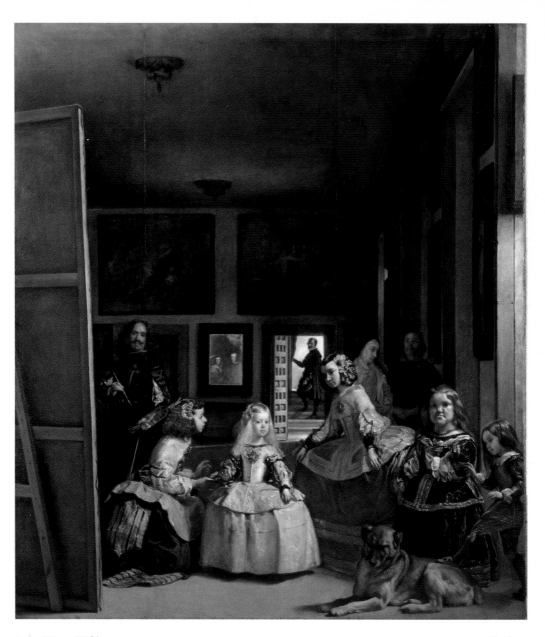

29 Diego Velázquez Detail of 29
Las Meninas, 1656
Oil on canvas, 318 × 276 cm
Madrid, Prado

With unprecedented boldness, Velázquez inserted himself as a major figure within this portrait of the royal family, transforming with his powers of invention a long-established genre.

Emblem and allegory

Alongside his self-portrait, Alberti's plaquette (4) displays the small winged eye that served as his personal emblem. This image seems to have represented the swift, near-divine power of the inquiring mind. The hieroglyphic character of such emblems was intended to evoke reflection on its veiled meaning, and the deciphering was to elucidate the nature of the man himself.

Such emblems gave rise to an entire literary genre—a form of erudite picture-book, often written in Latin—and were much the vogue in the sixteenth and seventeenth centuries. The proverbs and adages these books collected and interpreted were often employed by artists to provide subjects for their works, and at times the emblem's woodcut images served as the basis of their compositions. So it was when Rubens painted himself with his first wife, Isabella Brant, possibly for his new father-in-law (30).

For the couple's portrait set amid their garden bower, Rubens adapted an image from the famous emblem book of Andrea Alciati (31). As they grasp right hands like Alciati's couple, they enact the classical gesture that signified the solemn vows of marriage. Rubens has, however, exchanged Alciati's

30 Peter Paul Rubens
Rubens and Isabella Brant in the honeysuckle bower, c1610
Oil on canvas, mounted on panel, 178 × 136 cm
Munich, Alte Pinakothek

Rubens sits higher than his wife, to symbolize the husband's role as master of the family, while Isabella sits upon the ground, echoing a traditional pose of humility. Yet the forms of the composition, with their many interlocking curves, bind the figures in a visual unity that complements their gesture of joined hands.

31 Anonymous artist
Emblem CXC from Andrea Alciati's
Emblematum Liber: Conjugal Fidelity

**"See the girl who is joined to her husband with her right hand;
See how she sits, how the puppy plays at her feet?
This is the image of fidelity. If the fire of Venus nurtures her,
Happily on her left there will be the branch of an apple tree.
For apples are the fruits of Venus. Thus did Hippomenes
Overcome Atalanta; thus did Galatea seek a husband."**

138 AND. ALC. EMBLEM. LIB.

In fidem uxoriam. LXI.

Ecce puella uiro que dextra iungitur, ecce
Vt sedet, ut catulus lusitat ante pedes?
Hæc fidei est species, Veneris quam si educat ardor,
Malorum in læua non malè ramus erit:
Poma etenim Veneris sunt, sic Schenëida uidt
Hippomenes, petijt sic Galathea uirum.

apple tree, sacred to Venus, for a honeysuckle vine that, with its perpetually entwined tendrils, offered a powerful symbol for the steadfastness of their love: its fruits, reputed to grow sweeter as one became accustomed to their taste, provided a charming prophecy for their future wedded bliss.

These characteristic aspects of the emblematic tradition had a long life, and at the close of the nineteenth century Henri Rousseau employed them again for an allegorical portrait of himself and his second wife, painted in the year of their wedding (**32**). Here the clinging ivy that surrounds them once again echoes the symbolism of their joined hands. But the paradise of their new marriage was haunted by the artist's past. Hovering above their bower, Rousseau added a portrait of himself (distinguished by the beard he had worn in earlier years) along with that of his first wife. Yet the painting's original sense of foreboding waned, and with the passing years the work came to change its meaning. When Rousseau finally exhibited it, some eight years later, upon reflection he rechristened it *Philosophic thought*.

No allegory was more apt for a self-portrait than that of Painting itself. In her sole surviving self-portrait, Artemisia Gentileschi declared herself the personification of *Painting* (**33**). The attributes which identify her derive

32 Henri Rousseau
The Present and the Past (Philosophic thought),
1899
Oil on canvas, 85 × 47.5 cm
Philadelphia, Barnes Foundation
Rousseau's painting was accompanied by a brief poem:
"Separated one from the other,
From those who they loved,
Once more both are united,
Remaining faithful to their thought."

33 Artemisia Gentileschi
Self-portrait as an *Allegory of Painting*, 1630
Oil on canvas, 96.5 × 73.7 cm
British Royal Collection
The portrayal of the artist at work is transformed by allusion to a well-known personification of her profession. This was an identification only possible for a woman artist, since the italian noun – *la pittura* – being feminine, had to be represented as a female.

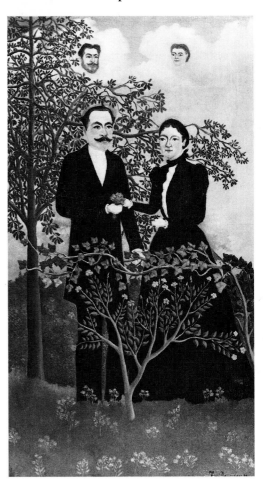

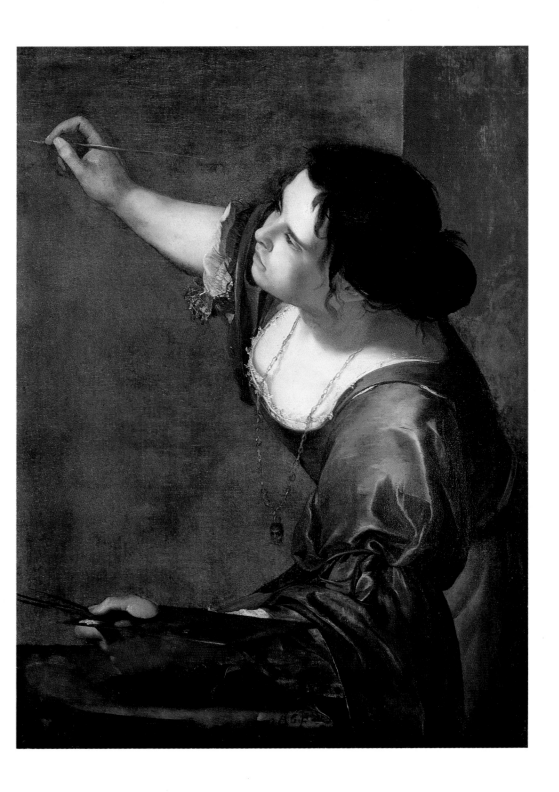

from another emblem book, Cesare Ripa's *Iconologia*: the gold chain and its pendant mask, the unkempt hair that signals her inspired state, and the coloristic treatment of her shot-silk garments all symbolize Artemesia's artistic skills. Ripa's emblem had already appeared on the reverse of the 1611 portrait medal of Lavinia Fontana, but in her own self-portrait Artemisia was to transform its role, from one of analogy to one of identity.

The imagery of these emblem books established conventions for the representations of abstract ideas, often specifically intended for the use of artists. Some, however, preferred to devise their own variations, as Poussin appears to have done for his personification of Painting, included in a self-portrait made during the jubilee year 1650 (**34**). Behind the artist stands a series of empty canvases that await him. On another at the left is depicted an image of *Painting*, whose presence transforms the work into an allegory of both friendship and painting, as we know from the description given in the biography written by his friend Gian Pietro Bellori: "At the back ... is painted the head of a woman in profile, wearing over her forehead a diadem with an eye: this is the figure of Painting, and two hands appear to embrace her, which represent a love of painting itself, and the friendship to which the portrait is dedicated."

The art of painting was also personified by its greatest practitioners, with whom a painter might strive to identify himself. Poussin's contemporary, Rembrandt, did so in a most ingenious fashion in his Kenwood House self-portrait (**35**). Rembrandt identified himself as a painter not only with brushes, palette, and mahlstick, but by the huge geometric forms inscribed on the wall behind. These recall a legend of Giotto's genius, as told in the artist's biography written by Giorgio Vasari. It was said that the Pope had sent an emissary to

34 Nicolas Poussin
Self-portrait, 1650
Oil on canvas, 98 × 74 cm
Paris, Louvre
Poussin began the project of his self-portrait in 1649 for his French patron, Chantelou, after failing to find someone to whom he might entrust the task. Displeased with his first efforts, the artist painted this version, which he proclaimed to his patron both "the better work and the better likeness."

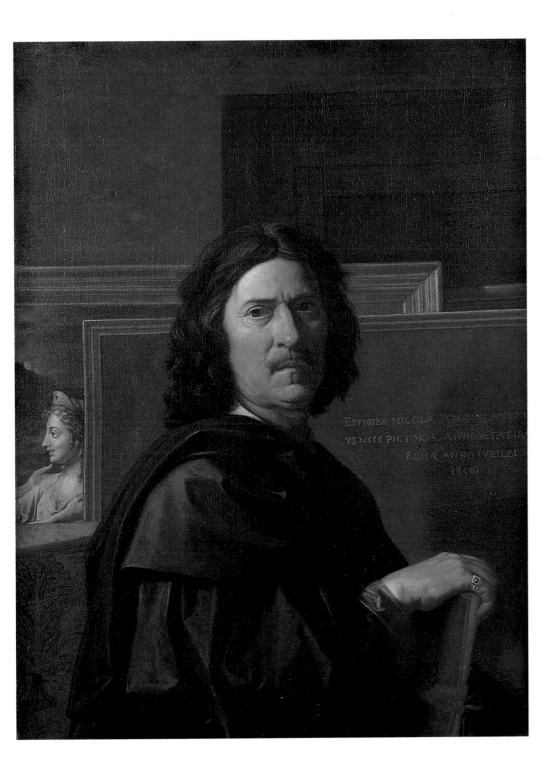

EFFIGIES NICOLAI POVSSINI ANDE
YENSIS PICTORIS ANNO ÆTATIS
ROMÆ ANNO IVBILEI
1650.

49

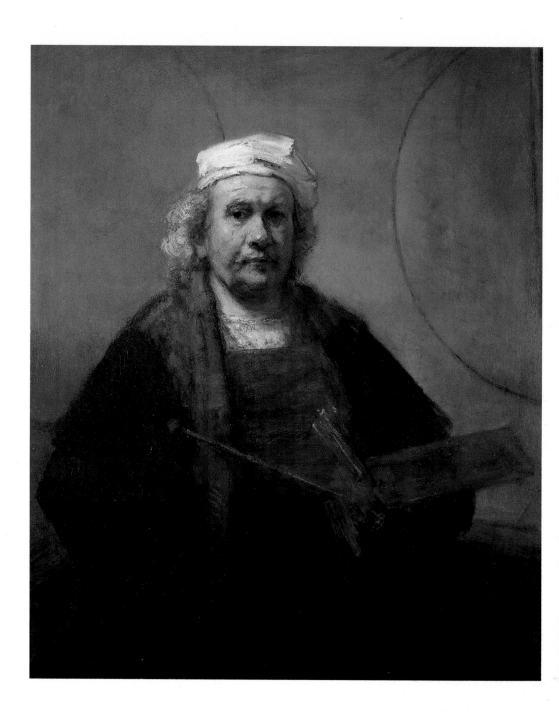

Tuscany, to meet the famous painter and see his work. Before leaving Giotto's studio, "he asked for a small drawing to send to his Holiness. Giotto, who was most pleased, took a sheet of paper and on it, with a brush dipped in red, held his arm firmly to his side like a compass, and turning his hand, made so perfect a circle that it was a wonder to see." Standing proudly before such circles of his own, Rembrandt reenacted the legend, as if to proclaim himself Giotto's legitimate heir.

Courbet's monumental *The Artist's Studio* (**36**), perhaps the greatest of these allegories, represented painting, friendship, and still more. The artist stated in the work's full title that it was a "real allegory," thus one fashioned not from abstractions and personifications, but from the realities of life, here assembled and visualized by the painter. In Courbet's studio are gathered together his friends, as well as actual portraits of typical figures who represent all walks of life—as he said, "society at its peak, at its bottom, and its mean."

At the center of the scene sits Courbet himself. At work on an empty landscape—painted indoors!—he serves to personify the painter's vision, the crowded studio to symbolize the world around him. As an innocent youth and a nude model stand to watch, Courbet paints from his imagination, and thus declares the power of his art to render the true Realism—the product of ideas as well as fidelity to Nature and appearances.

35 Rembrandt van Rijn
Self-portrait, *c*1660–65
Oil on canvas, 114.3 × 94 cm
London, Kenwood House

Like Titian before him, in his later years Rembrandt began to paint more freely, as can be seen by comparing this work with his earlier self-portrait (**39**). Gone is the former attention to detail, replaced here by majestic sweeping strokes of the brush and vigorously worked textures of paint.

OVERLEAF **36 Gustave Courbet**
The artist's studio, 1855
Oil on canvas, 359 × 598 cm
Paris, Musée d'Orsay

In a letter to his friend Champfleury, Courbet described his work: "It's the moral and physical history of my studio ... these are the people who assist me, sustain me in my idea and participate in my activity. These are the people who thrive on life, and who thrive on death ... – in a word, it's my way of seeing society in all its interests and passions"

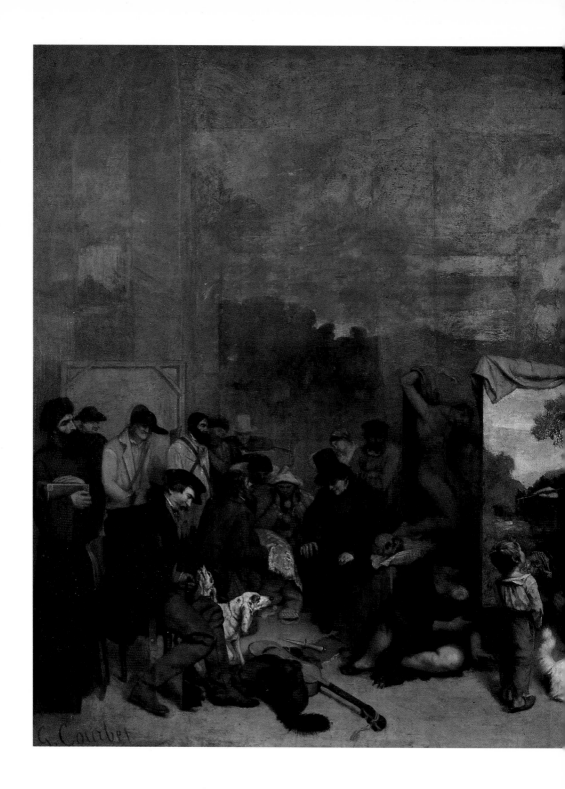

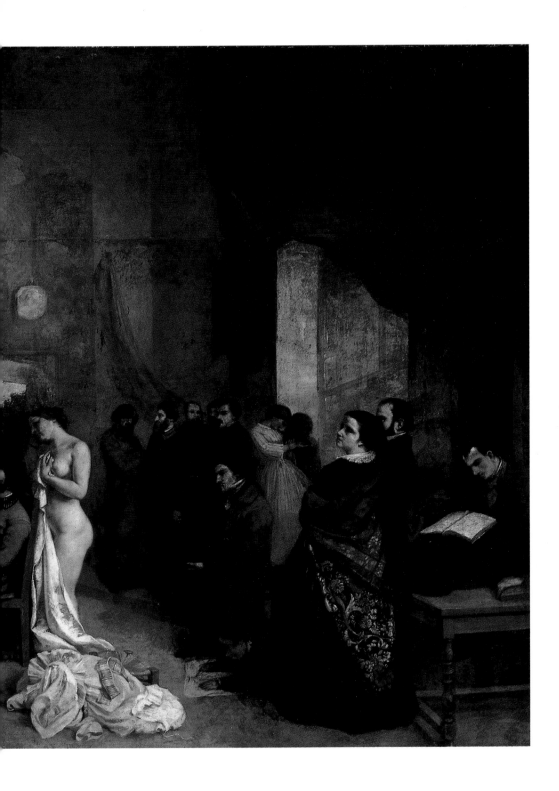

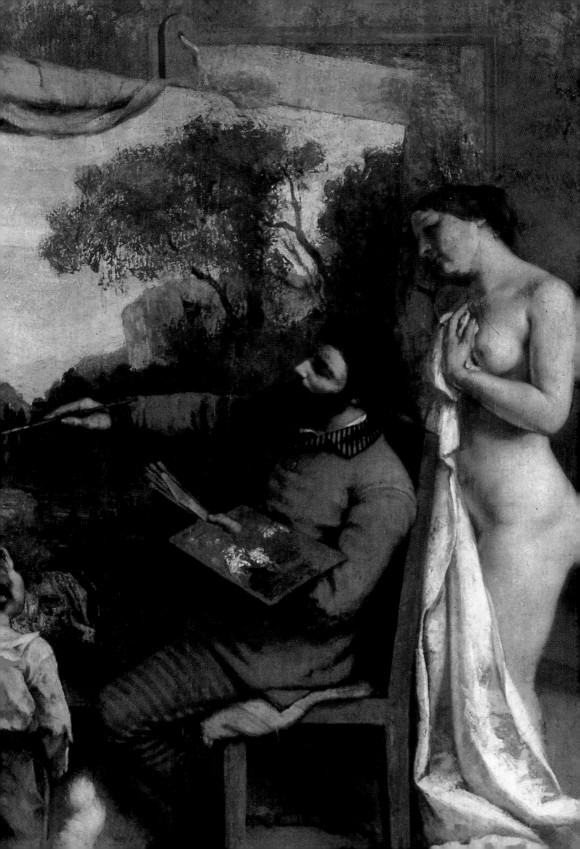

Questions of style

The vividness of Chardin's naturalism proved sufficient justification for his style, which was founded upon his careful observations of the stuff of everyday reality. The works of other artists have provided eloquent examples of their individual styles in the recording of appearances. Ingres heightened the vividness of his image with his painstaking replication of detail; Alberti and Leonardo chose to infuse theirs with a classical spirit; Dürer's fidelity to his observations led him to render even the mirror's distortions; Desportes produced a self-portrait with an artifice more appropriate to his customary still lifes; Velázquez, Courbet, and Rousseau constructed elaborate allegories that redefined our perceptions of their self-portraits and their relation to the world around them. In all of these instances, questions of style lay at the heart of the pictures' meanings.

As an act of emulation, the distinctive style of a particular earlier artist might play a fundamental role in the meaning of another's self-portrait. Upon his return from Italy, Dürer fashioned himself in the style of Leonardo. In the following century Rembrandt would base another of his many self-portraits on the bold and confrontational format he found in a work of Titian, which he saw in an Amsterdam auction room (both works are now in the National Gallery, London). In turn, the self-portraits of several later artists borrowed a portion of their distinctive character from the works of Rembrandt.

Among them was the English Neoclassical painter Joshua Reynolds. In an early self-portrait (**38**), Reynolds raises his hand to shield his eyes from the glare, thus casting a dramatic shadow across his face. The face cast in shadow is a hallmark of Rembrandt's por-

Detail of 36
The sources from which Courbet constructed the *Studio's* "realism" were varied: for his own features, Courbet adapted a self-portrait, painted the previous year; the figure of the naked model was based, according to Courbet himself, on a photograph.

38 Joshua Reynolds
Self-portrait, *c*1748

Oil on canvas, 63 × 74 cm
London, National Portrait Gallery

Painted just before the young artist's visit to
Italy, this is the only one of Reynold's self-
portraits in which he depicted himself at work.
Its casual attitude would later be replaced by
more dignified presentations.

37 Robert Philipp
Self-portrait, 1950

Oil on canvas, 33.3 × 33.6 cm
New York, National Academy of Design

The American painter's self-portrait, with its
distinctive gesture, can only have been
intended to recall that of Joshua Reynolds (38).

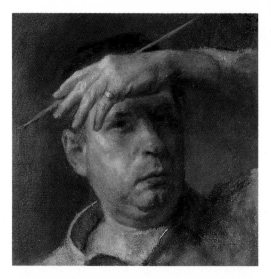

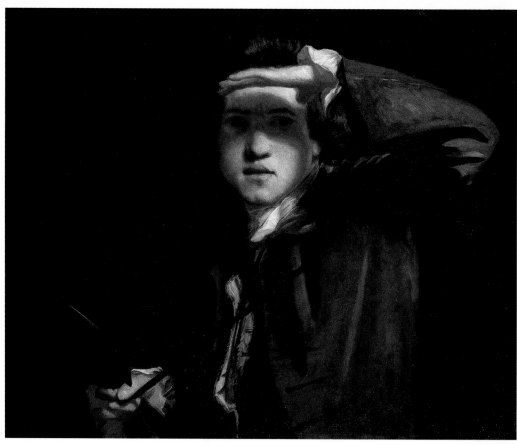

traits, as in the very earliest known, now in Kassel (**39**). Reynolds may have also taken the specific gesture from one of Rembrandt's unfinished etchings (**40**). In our own time, one source or the other—or indeed, both—seems to have been used by Robert Philipp in 1950, when he reprised the gesture as the central motif of his own self-portrayal (**37**).

The importance of an artist's individual style became more pronounced in the modern era, as the arts began to free themselves from a general standard of naturalism, and as innovation challenged the power of tradition. With the desire to break from conventions, and to establish an independence from the past, modern artists sought styles they felt were suited to their own times. They saw general truths in their own observations, and they sought the universal in their pursuit of the individual—no more so than Gauguin and Van Gogh did at the end of the last century.

In 1888, Van Gogh asked his friend Gau-

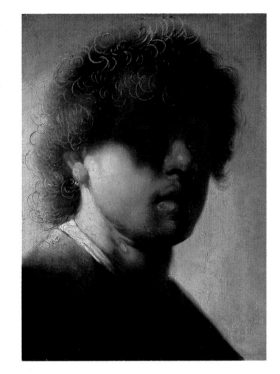

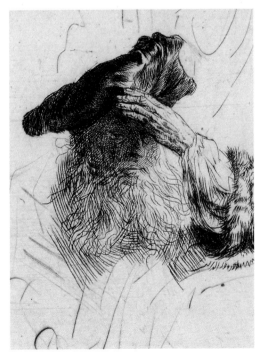

39 Rembrandt van Rijn
Self-portrait, c1629
Oil on panel, 23.5 × 17 cm
Kassel, Staatliche Gemäldegalerie
The extensive shadows on the face display the young Rembrandt's ability to employ the fullest possible range of tones in rendering his likeness. The brilliant highlights of the hair were produced by scratching through the painted surface with a sharp object to reveal the contrasting underpaint.

40 Rembrandt van Rijn
Portrait of an old man (detail), 1639
Etching
Despite its unfinished state the etching demonstrates Rembrandt's focus on its central motif, and his concern to render in stark contrast the light on the hand and the shadow it cast on the face.

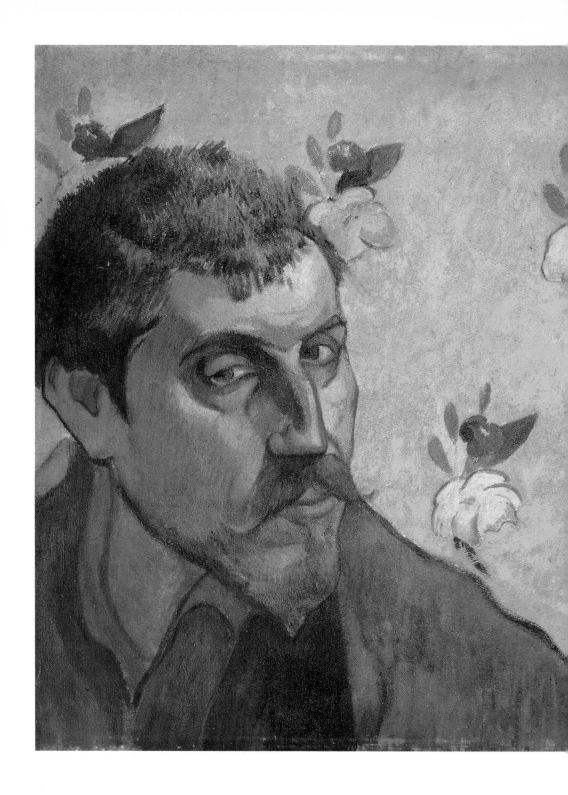

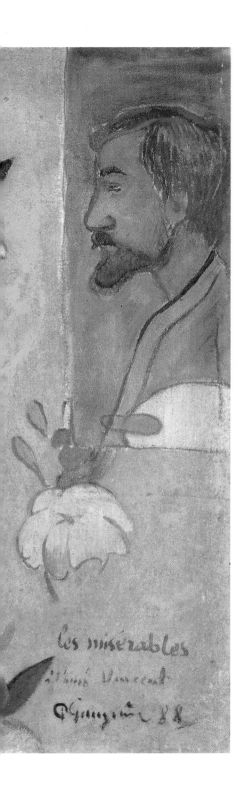

guin for the gift of a self-portrait. Gauguin responded with a painting he inscribed to his colleague, borrowing for his title that of Victor Hugo's novel, *Les Misérables* (**41**). Gauguin was extremely pleased with his work, as we know from a letter in which he described the painting. He acknowledged his kinship with the rogue hero of Hugo's novel, and proclaimed the picture a symbolic vision of the artist as an Impressionist: "I believe it is one of my best efforts, absolutely incomprehensible (for example) so abstract is it. First the head of a brigand, a Jean Valjean, personifying a disreputable Impressionist painter likewise burdened forever with a chain for the world. The drawing is altogether peculiar, complete abstraction. The eyes, the mouth, the nose, are like the flowers of a Persian carpet, thus personifying the symbolic side.... Chamber of a pure young girl. The Impressionist is such a one, not yet sullied by the filthy kiss of the Académie des Beaux-Arts."

Shortly after receiving the gift, Van Gogh painted a self-portrait for Gauguin in return (**42**). Stark and severe by contrast with his friend's, it was no less symbolic. It too attempted to capture the artist's spirit as well as his image, and comparison of the two paintings

41 Paul Gauguin
Les Misérables, 1888
Oil on canvas, 45 × 55 cm
Amsterdam, Rijksmuseum

In his letter to his friend, the painter Schuffenecker, Gauguin vividly described the painting's visual effect: "The color is color remote from nature; imagine a confused collection of pottery all twisted by the furnace! All the reds and violets streaked by flames, like a furnace burning fiercely, radiating from the eyes, the seat of the painter's mental struggles. The whole on a chrome background sprinkled with childish nosegays." The profile is that of his friend the artist Emile Bernard.

displays the vast differences in their natures as well as their art. All of this Van Gogh made clear in a letter to his brother Theo: "I have written to Gauguin, in reply to his letter, that if I too were permitted to enlarge my personality in a portrait, I did so seeking to render in my portrait not only myself but an Impressionist in general. I had conceived this portrait as that of a *bonze* [a Buddhist monk], a simple worshipper of the eternal Buddha. And when I put the conception of Gauguin and my own side by side, mine is grave but less despairing."

An attempt to project an interior state of mind also characterized the work of Edvard Munch. The young Norwegian artist's 1895 portrait (**43**), painted in a period both of great artistic production and of failing health, culminated a series of self-portraits all marked by the spectre of death. Like many of the haunting images that sprang from Munch's imagination, this one, too, had its origins in a previous work of art. The preparatory drawing, in which the artist's cigarette-holding hand is hideously enlarged, reveals a debt to Goya's *Duendicitos* (Little goblins) from the series of prints known collectively as the *Caprichios*. In the painting the hand was depicted on a more natural scale, yet remained a focus of attention; in a lithographic self-portrait of the same year it reappears in skeletal form as a *memento mori*. The Oslo self-portrait conveys the psychological intensity of the artist, whose deteriorating state of mind was to lead to his mental collapse in 1908. The smoke of Munch's cigarette seems to surround him as he stares out of the shadows; his illuminated face seems to reflect the disquiet with which he confronted his own image.

The new intensity which modern artists sought to convey was not always appreciated, nor always understood. For example, the unnatural and often violent imagery of the

42 Vincent van Gogh
Self-portrait for Gauguin, 1888
Oil on canvas, 62 × 52 cm
Cambridge MA, Fogg Art Museum
To effect his identification with the severity of a Buddhist monk, Van Gogh depicted himself starkly, with the simple costume and the closely shorn hair of an acolyte. In addition, he slightly distorted his features, attempting to give to the eyes in particular an "oriental" character, as he said in a letter, "like a Japanese."

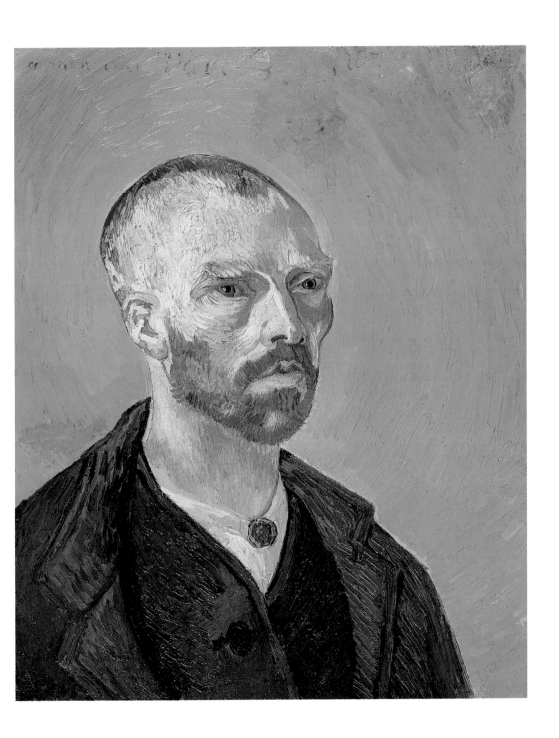

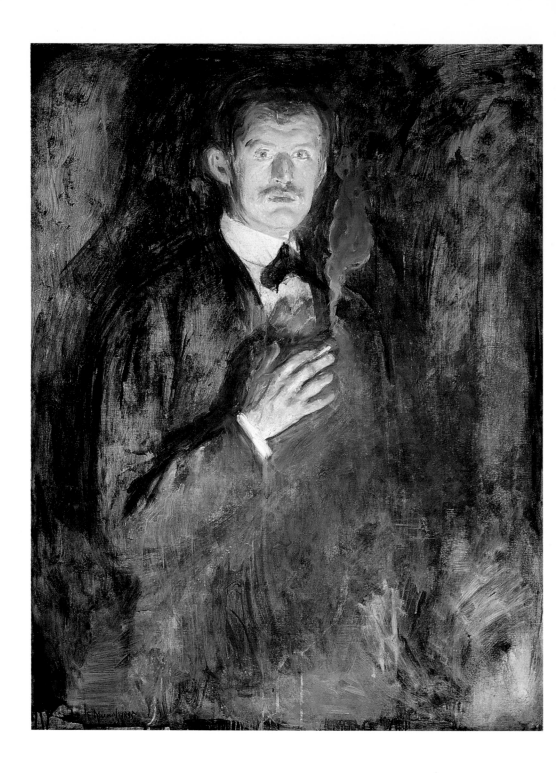

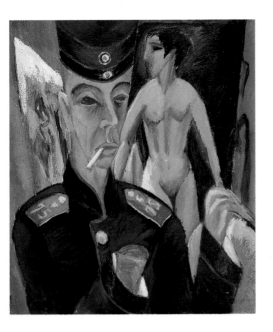

44 Ernst Ludwig Kirchner
Self-portrait as a soldier, 1915
Oil on canvas, 69.5 × 60.5 cm
Oberlin, Museum of Art

To heighten the effect, Kirchner pointedly corrected the mirror's natural reversal of his image. Thus it is the hideous loss of his right hand – his painting hand – that is presented to the beholder's sight.

43 Edvard Munch
Self-portrait, 1895
Oil on canvas, 110.5 × 85.5 cm
Oslo, National Gallery

This modern image of the melancholic artist's self-confrontation reveals Munch's profound affinity with his artistic predecessor Dürer, whose work evokes a similar unease with the task of self-scrutiny.

German Expressionists originally elicited indignation and public rejection. In the face of such a hostile response, the self-portrait could become a manifesto for the new style, as did that of Oskar Kokoschka. His painted terracotta self-portrait, entitled *The warrior* (now in Boston), made direct reference to Kokoschka's role in the artistic controversy then raging in Vienna. The inaugural Viennese *Kunstschau* (Art Show) of 1908 had been the forum for the emergence of the Expressionist school, and was Kokoschka's first exhibition. His work in particular had been savaged by the press. It was in the International Kunstschau of the following year that Kokoschka exhibited *The warrior*. Vividly portraying his gaunt and battered figure, it signaled a recognition that his work had become the battleground for the new style.

In such intensely personal images, style seems to become reality, as it does in Ernst Ludwig Kirchner's self-portrait as a soldier (**44**), which presents a haunting vision of the artist's destiny in an indifferent society. His fears found expression in a violently disturbing and prescient image of his fate. Kirchner's self-portrait represents the nightmare of military service, which he had just entered as a recruit. In his new uniform he stands in the middle of his studio, indistinguishable from the vivid images on the paintings visible behind him. The image depicts the gruesome spectacle of an artist maimed by the horrors of war. Devastated by the violence around him, Kirchner sought refuge in his art, but could not survive the madness of his times. Among those branded "degenerate artists" by the Nazis, he committed suicide in 1938.

Modernity had changed art as well as the world. The traditional forms were transfigured by new visions, new techniques, and new technology. For the art of self-portraiture, this

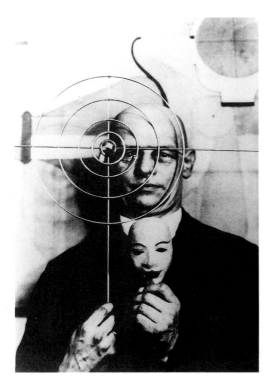

45 Oskar Schlemmer
Self-portrait with mask and wire disk, 1931
Photograph
Stuttgart, Staatsgalerie, Oskar Schlemmer Archiv
With the addition of props and a view of his
monumental *Mythical figure* (1923) behind him,
Schlemmer transformed the photographic
portrait into a recording of what was, in effect,
a three-dimensional collage.

is reflected clearly with the acceptance of photography as a legitimate art form. With its aid, the problem of attaining a likeness was easily solved, yet the traditional role of artistic style in the physical making of the image had to be considered anew. The opposing forces of tradition and innovation can be seen in the Bauhaus artist Oskar Schlemmer's 1931 self-portrait, which therefore provides an appropriate conclusion (**45**).

The photograph, which faithfully captured Schlemmer's appearance, has been transformed into a kind of collage. As earlier artists had done, Schlemmer posed himself before one of his own works of art (the *Mythical figure* of 1923), and added a series of props, which serve emblematically to augment the portrait and to indicate its meaning. Some of these uncannily recall certain earlier examples: the mask reprises the pendant worn by the personification of painting in Poussin's self-portrait (**34**); the circular motif of the wire disc suggests the O's of Giotto and Rembrandt (**39**); and the painted head at the upper right (itself often considered an abstract self-portrait) calls to mind the portrait of Emile Bernard behind Gauguin (**41**). Whether intentionally or coincidentally, by means of this entire sequence of associations, Schlemmer's unique and novel image effectively takes its place within the tradition of self-portraiture.